intimate visions

PREFACE

The voice of the artist is the prophetic voice of man.
Dorothy Norman, *Twice A Year*, 1942

Dorothy Norman's photographs document her personal sense of the sacred in everyday life. Her revealing portraits of famous artists and writers she knew, her interior shots of An American Place that capture the fullness of empty space, and her quiet photographs of New England churches and landscapes all represent her own transcendental quest for meaning and purpose in life. They seek to go beyond the mundane and the material, as her mentor Alfred Stieglitz encouraged her to do. Since even before the beginning of the century, Stieglitz had sought to demonstrate the power of the camera to penetrate the veneer of the infinite – to reveal the mysteries of the universe. These photographs are a product of that tradition. Indeed, Dorothy Norman's career from the thirties to the sixties as an editor, a publisher, a writer, and a photographer might be seen as a legacy of Stieglitz's vision.

8 In 1927, Dorothy Norman, a young woman of only twenty-two, wandered into The Intimate Gallery, on Park Avenue in New York City. Like Alice in *Alice in Wonderland,* she had fallen into a world where everything seemed different, fascinating, and charged. On the walls hung

Dorothy Norman – Hands with Camera, 1932
photograph by Alfred Stieglitz
Philadelphia Museum of Art:
From the Collection of Dorothy Norman

in providing me with wide access to material. Also Mary Donlon, who compiled the bibliographical and chronological references. Mrs. Norman's present assistant, Deborah Roan, has continued to play an important part in the preparation of this book; for her invaluable assistance as a copy editor and associate, I am grateful to Kathryn Mackey.

I also thank the Philadelphia Museum of Art for granting permission to reproduce a number of images from its holdings in this book. These include several images of Dorothy Norman's work and the cover photograph taken by Alfred Stieglitz. In addition, the National Gallery of Art generously allowed reproduction of two images from their Alfred Stieglitz Collection. For additional loans I thank Nancy Wu, Asa Ivry and the Howard Greenberg Gallery.

I am especially thankful to Sarah Lazin, whose tireless efforts have brought this book to publication, and to Carol Lynn Vazquez, who has been a constant source of support and encouragement.

Miles Barth

ACKNOWLEDGMENTS

In November of 1985, I was asked by William K. "Bill" Jacobs, a friend of ICP and close personal friend of Dorothy Norman, if we would be interested in receiving a gift of several of her photographs for our Permanent Collection. I responded very positively to the idea and, shortly thereafter, Bill made an appointment for me to meet with Mrs. Norman to review the prints from which we were to make our selection. Thus began a long and most enjoyable relationship with Dorothy Norman and her photographs. As my interest in Norman's work grew, I was surprised to learn that there had never been a retrospective exhibition of her work. Bill encouraged me to pursue my interest in an exhibition and book devoted to these photographs. His inspiration and kindness blessed this project from the start, and it is my sincere regret that he did not live to see its realization. This publication is dedicated to his memory.

Support for the initial publication research and preparation was provided by a grant from The Andrew W. Mellon Foundation.

There are many others who assisted me. When I first began working on the project, Ethel Bobb, Dorothy Norman's assistant at the time, was most helpful

6

CONTENTS

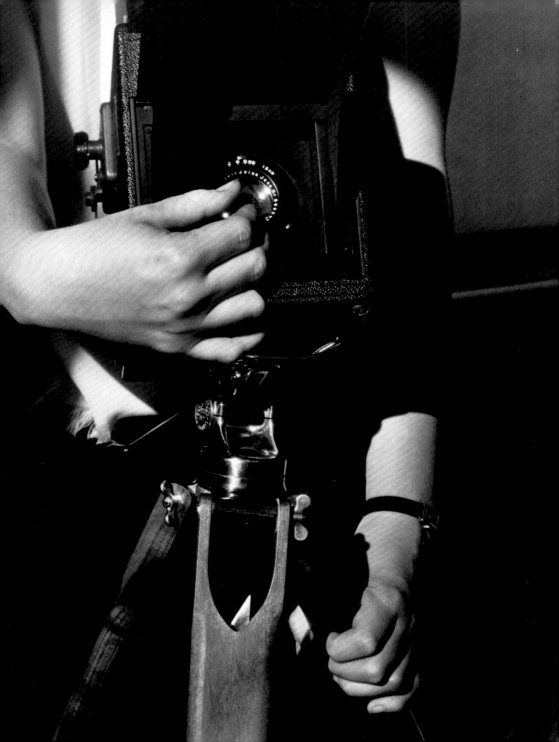

paintings by John Marin: buildings, seascapes, lyrical statements. Talking uninterruptedly, the gallery's proprietor, Alfred Stieglitz, was discussing the meaning of art and life, a subject he had been exploring since the beginning of the century. Unable to get the attention of Stieglitz, who frequently ignored potential buyers, Norman picked up a statement about the gallery's purpose. "The Intimate Gallery," she learned, "is a Direct Point of Contact between Public and Artist. It is a Room with but One Standard. Alfred Stieglitz has volunteered his services and is its Directing Spirit." Though she did not know it then, the visit changed her life.

She was not present at the creation of the idea that sustained her – that art and the lone artist could and should shape society. Alfred Stieglitz began pounding that idea into the American consciousness in 1905 when he founded 291, a small gallery he created with Edward Steichen on Fifth Avenue in New York, just north of Greenwich Village. The purpose of the gallery was to exhibit photography, to advance modern art, and, most important, to represent his conviction, as he wrote in 1916, that "no public can help the artist unless it has become conscious that it is through the artist that it is helped to

develop itself." Following 1917 and the carnage of World
War I it became increasingly difficult to believe in the
efficacy of art by itself to serve the public, although Stieglitz,
unlike many of his younger associates, did not give up his
faith in art's power to rebuild society unaided by changes in
political and economic institutions, even if the flame that
fired his faith was dwindling.

 Dorothy Norman helped rekindle Stieglitz's
vision and his belief in himself. "I believed in the thing he
was," she said.

 Dorothy Norman had come to New
York City from Philadelphia in 1925 with her new husband,
Edward, whose father had helped found Sears, Roebuck.
She was born in 1905 into a well-to-do Jewish family (though
not nearly as wealthy as the Normans), and educated
at the Wheeler School in Providence, Rhode Island (where
she was one of the first Jewish students), Smith College, and
the University of Pennsylvania. A rebel who instinctively
chafed at the status quo, Dorothy refused to settle into a life
of "bridge and mah-jongg and petty gossip" as she described
it in her memoir, *Encounters*. Later, she attributed her liberal
politics — which included commitments to civil liberties,
civil rights, and the independence of India — to the guilt she

said she experienced growing up in a cocoon of protection and privilege. Instead of following the circumscribed dictates of social convention for young women, she volunteered to work for Roger Baldwin's Civil Liberties Union, joined the board of the Urban League, and helped Margaret Sanger disseminate information about birth control, all considered radical activities in the Twenties and the Thirties.

Civil liberties, civil rights, and birth control, however, did not fulfill the young Dorothy Norman's search for her place in the world. Interested in art, she found her way to The Intimate Gallery. As she wrote in her autobiography, she returned again and again to "listen to Stieglitz, read about him, watch him function, look at his photographs, talk with him, and begin to fathom that he represents an approach to life I have been seeking in the world around me but had not found." She soon became the unofficial keeper of his legacy — recording his thoughts, publishing two volumes of testimonials about his place in American life, and writing a definitive biography of him in 1973. Stieglitz, it can be said, provided a focus for her — and not only in photography.

Though separated in age by more than forty years and married to other people, Dorothy Norman

and Alfred Stieglitz also became lovers. They filled needs in each other missing in their respective marriages. Norman's adoration of Stieglitz was something he wanted, particularly after his wife, Georgia O'Keeffe, began to spend half the year alone in New Mexico. "I know you love my spirit in my work as I love the spirit in whatever you do," he wrote Norman in 1929. "You know me," he wrote on another occasion. "You are the only one who does or ever did — or ever will — completely." For her part, Stieglitz, she said, was a 'lifeline.'

Soon after their relationship intensified, plans were made to demolish the building in which The Intimate Gallery was located. Along with the photographer Paul Strand and O'Keeffe, with whom Norman's relations might at best be described as frosty, Norman persuaded Stieglitz to open another gallery — An American Place — on Madison Avenue in 1929. She took on the chief responsibility to raise funds for the new center that served as Stieglitz's focus for the last sixteen years of his life. It also provided her entrée into the heady world of New York's avant-garde. She got to know not only the artists in the Stieglitz circle — John Marin, Arthur Dove, Marsden Hartley, Charles Demuth, and Gaston Lachaise — but also the writers who frequented

13

the gallery to which she came every day after lunch: Lewis Mumford, William Carlos Williams, Theodore Dreiser, Paul Rosenfeld, Sherwood Anderson, Hart Crane, and e.e. cummings among others. In 1934, with Waldo Frank and other editors, Norman pulled together the talents of these writers and artists and published *America and Alfred Stieglitz*, a collection of essays about Stieglitz and his place in American culture.

By 1938 Norman felt confident enough to launch a venture of her own – a periodical she decided to call *Twice A Year: A Semi-Annual Journal of Literature, the Arts and Civil Liberties.* Though dedicated to Alfred Stieglitz, published out of An American Place, and based on his belief that public life finds its best expression through the unhindered efforts of the artist, the new journal represented Dorothy Norman's synthesis of concerns that had preoccupied her since she came to New York. Taking an unspent wedding gift of ten thousand dollars, she joined together in one publication her interests in the arts and social action. She had been disappointed that artists like Stieglitz remained insufficiently disturbed by the impending threat of fascism, and also thought that the current crop of little literary magazines focused their

attention too closely on fiction and criticism to have
the impact she wanted. In response to her proposal to start
a new magazine that would draw on the traditions of
Camera Work, The Seven Arts, and *The Dial,* Lewis Mumford
wrote her, "This is a place where you, as a woman, have
an enormous advantage, if you have the courage and
persistence to use your special powers and opportunities.
You might influence the feeling and thought of a whole
generation, if you would devote yourself to bringing into a
social-intellectual relationship the creative spirits around
you." Like Mumford, Norman held high hopes that cultural
criticism, modern artistic expression – including photography,
of course – and poignant discussions of political threats to
civil liberties could influence public thinking.

From its start in 1938 to its final publication
ten years later, *Twice A Year* recorded the international liberal
intelligentsia's preoccupations and frustrations, while also
sadly documenting the inadequacy of the prophetic vision by
itself to alter the tragic course of history during those years.
The first issue established the high standard, defined the
agenda, and set the parameters for the new periodical. As
liberals reexamined their opposition to war in 1938, *Twice A
Year* published Rainer Maria Rilke's wartime letters and

work by and about Randolph Bourne, a hero for an earlier generation of young intellectuals who believed in American culture's promise and the role of the intellectual to help advance it. It continued with an essay by Thoreau praising John Brown, an article by André Malraux examining the issues of the Spanish Civil War, and a piece by Ignazio Silone opposing fascism. In addition, Norman, paying the going rate of a penny a word, printed in her premier volume work by e.e. cummings, Franz Kafka, Anaïs Nin, and Kenneth Patchen as well as documents, including one by Roger Baldwin, on the condition of civil liberties in America. The edition also included four reproductions of Alfred Stieglitz's photographs and an initial statement of purpose conveying Norman's conviction that "the voice of the artist in life, pursuing his lonely course, affirming and reaffirming his faith . . . (will) help to make available a vision upon which civilizations that have been temporarily crushed are rebuilt."

16

Future issues included writing by Thomas Mann, Franz Kafka, Sherwood Anderson, and Federico Garcia Lorca; critical essays by Albert Camus, Stephen Spender, as well as Richard Wright, who in 1946 became an associate editor reporting from Paris. His series on

discrimination in America published after World War II remains compelling as do the photographs Norman printed in 1945 in *Twice A Year* of the piled corpses discovered at Buchenwald and one of the two atomic blasts over Japan. These she juxtaposed with Ansel Adams' *Tree with Snow* and an Alfred Stieglitz *Equivalent,* thereby signalling the powerlessness of the prophetic vision to reshape the awful reality *Twice A Year* did not shrink from documenting. In the final and tenth anniversary edition, 'Art and Action,' published in 1948, Norman repeated the theme that had guided her periodical's publication — her "belief that art without action in its image is as valueless as mere action that is performed without mirroring the feeling embodied in art." All two thousand copies of the last issue, like the first, sold out.

Although it is difficult (if not impossible) to measure the impact of a literary journal on public thinking, the young critic Alfred Kazin's comment to her in 1942 suggested that Norman's journal had an influential audience. He wrote her, "I started to read in *Twice A Year* again, and felt the excitement that rises from the sense of the lean, hungry, inviolate artistic man . . . You've caught that, Dorothy, so well — with Stieglitz radiant over it. And that's

why I am moved by looking, being with the journal."

In 1949 Norman's life took a new direction. She had been a *New York Post* columnist since 1942, writing about civil liberties, discrimination, and also Indian independence, a movement which became increasingly important to her after Stieglitz's death in 1946. On one of Jawaharlal Nehru's early visits to New York City, she met and became close friends with the Indian leader, and helped him advance his cause in the United States by introducing him to opinion makers in New York. Norman also published a two-volume compilation of his speeches and writings in 1965 and, in 1987, a book of personal letters his daughter, Indira Gandhi, wrote to her over the decades of their friendship.

Nor did Norman neglect the arts. In 1955 she selected the well-known captions for Edward Steichen's popular photographic exhibition "The Family of Man." She also became interested in myth, which she thought performed the same function as art: putting mankind in touch with the infinite. She organized an exhibition, 'The Heroic Encounter,' at the Willard Gallery in New York in 1958, and published a book titled *The Hero: Myth/Image/Symbol* a decade later.

These activities, like her earlier efforts in the Thirties and Forties, found Dorothy Norman in the background. She worked best as a facilitator, an effective promoter, as it were, of what she believed in — visionary art, the liberal agenda in politics, and the place of myth in modern life — rather than as a person comfortable calling attention to herself.

The photographs presented here — work done between 1930 and 1955 — should be seen in that light. Although some have been exhibited before, they are basically private reflections that document Norman's personal sensibility, shaped as it was in part by her long relationship with Alfred Stieglitz. Small, they do not scream for attention. Rather, they are modest statements that reward careful consideration by recalling a lost sensibility when character and place, not verve and style, were the hallmarks of modern photography. In 1944 a curator at the Museum of Modern Art likened them to the poems of Emily Dickinson: private, quiet, intimate.

Edward Abrahams

19

INTRODUCTION

Dorothy Norman

From the very first I lived through the eye. I have always been spellbound by beauty — faces, flowers, places, shells, New England spires, the feeling of white. Alfred Stieglitz's prints first opened my eyes to the power of photography in the hands of the artist. "You should have a $3^1/_4$-by-$4^1/_4$-inch Graflex camera. I'll buy one for you. Pay me back whenever you can. I'll show you how to get started and how to develop and print." Stieglitz spoke with such caring and simplicity that to accept his offer was as natural as to breathe. Yet I was startled since he said he never taught.

After the camera arrived, he said to shut down my lens as far as possible and take the longest exposures I could. He smiled and cautioned me: "Don't be afraid. Just go ahead — photograph, photograph, photograph. That's the only way you'll learn." I could photograph only with love. I had thought I would take satirical pictures. But no.

Looking through the reflex mirror in my beautiful Graflex opened up a new world, even though each day I was confronted by fresh problems. When my eyes were in focus, the background was not. Choices having to do with what to emphasize, what to sacrifice, had to be made in split seconds, and with exactitude. I became increasingly challenged and entranced.

I photographed, photographed, photographed.
I learned as much from Stieglitz making portraits of me as
I did from my own mistakes. While I remained still for him, he
made comical faces, stuck out his tongue, at times smiled
broadly — anything to make me laugh — before he settled down
to whichever self took over.

Influenced by Stieglitz at first, I nonetheless
refused to photograph anything I thought he would. At his
galleries I worked at will; Stieglitz liberated my entire being.
I sent and showed him manuscripts and photographs even
before they were perfected. He seldom offered suggestions
but was always encouraging, leaving me free, exalted. Showing
him even the incomplete helped clarify my aims; his not
offering criticism, but being loving and trusting, made me
solve problems myself.

Soon I worked with independence. Watching
him develop and print trained my eye. I noted he used a special
toning process that helped him achieve an extraordinary,
rich print quality, not attainable with standard materials. I never
asked him what chemicals he used. He had earned the right
to his discoveries without being questioned about them
because of his genius and lifetime of experiment and practice.
I followed only the advice he offered. The rest was up to me.

Through my lens, the world of flowers took on new dimension. Stieglitz told me I had courage to photograph them. He said he did not feel himself good enough to photograph or pick them. I never considered flowers in this way. I simply loved them.

From my first visit to An American Place, Stieglitz's last gallery, I loved the artists he showed. John Marin's work and that of Charles Demuth and Gaston Lachaise interested me most. Marcel Duchamp also appeared at the gallery. He had been photographed by Stieglitz at an earlier time. I photographed him when he spent a summer in East Hampton. Edgar Varese was one of the first composers I met in New York. His face was a constant source of wonder to me.

The death of Stieglitz in 1946 deprived me of the single channel through which my need for expression of the sacred in life could be released and shared. He photographed and communicated with awe and wonder, with dignity, devotion and love. Each time we spoke, or touched, or I showed him a new print, or each time I brought him a poem that came through as I wanted it to, I felt that it was part of a ritual.

Someone said: "What you remember of life is

not what you endure but life's richness." Stieglitz put both, I feel, into one surging song — all the pain is fused into affirmation. Without the deepest pain the song would not be significant and would not relate to life or act upon the beholder significantly. Stieglitz also said that art is the quintessence of wonder put into form.

In 1949 Jawaharlal Nehru and his daughter Indira Gandhi came to New York. He invited me to visit him in India the following year. I went and photographed them both. Nehru was elegant, handsome, and moved with an easy grace. None of the official photographs of him gave any inkling of his radiance. His intelligence was so vast that he often overshadowed those around him. His eyes were those of a searching, visionary intellectual. In Indira I sensed an underlying loneliness. She was both quick and observant, like Nehru, but veiled herself behind a shyness that both protected her from and deprived her of an easy communication with others.

I began to travel overseas more in the early 1950s. Bernard Berenson and Martin Buber intrigued me, as did Thomas Mann and his wife Katia, Jacques Prevert, who wrote the scenario for *Children of Paradise,* and the gifted writers André Malraux and Stephen Spender. Later when

23

I returned from India, Alexis St.-John Perse meant an increasing amount to me. His eyes were so intense I could barely see the rest of his face. He always gazed at me with an unsettling fierceness. Born on a small island off Guadeloupe, he had been a solitary person — an island — all his life. I tried to capture that in my pictures of him.

A number of writers close to Stieglitz — Waldo Frank, Lewis Mumford, Sherwood Anderson, and, in particular, Theodore Dreiser, entered my life in different degrees and I photographed them passionately. In photographing Dreiser I was aware of the sensitive face hidden behind a somewhat gruff mask. He was one of the few writers who looked exactly the way I expected. From our conversations, I could understand what impelled him to portray human beings with such a sense of identification — his own entrapment.

My photography grew and grew. It encompassed nature, people, and architecture — subjects I felt passionately about and loved. In size, my prints always remained small, but I tried to make the images as large and as bold and as beautiful as life itself.

When Miles Barth suggested that I have a retrospective exhibition of my photographs it was a

totally fresh concept to me. It meant reviewing my work after an absence from photography of almost twenty-five years. In all my photographic work my aim was to achieve the honesty of the form, to be true to the thing itself. My satisfaction came not from taking 'effective' photographs, but rather from the wonder of being able to capture moments that mattered to me. *Intimate Visions* is a record of my particular photographic process, a process in which what I saw and felt were more important than what I produced. I tried to describe the world around me as directly as possible, to respond to its shifting truths.

INTIMATE VISIONS
Miles Barth

Dorothy Norman is probably best known through her writings about the life, the ideals, and the impact of Alfred Stieglitz on American art and culture. Their relationship, beginning as a chance encounter, grew to a professional and intensely personal one during the last fifteen years of Stieglitz's life, and in some respects continues to this day for Norman.

It was not Norman's primary intent to pursue photography when she arrived in New York in the mid-1920s with Edward Norman, her new husband. Rather, it fit neatly into a developing array of concerns including activism for social change and women's rights, as well as interests in modern music, theater, and art. Norman also maintained a passion for writing poetry and criticism, and acted as editor and publisher of other aspiring writers' works.

Norman met Alfred Stieglitz at The Intimate Gallery, his second gallery, shortly after she moved to New York in 1925. Stieglitz, considered by many the father of twentieth-century American photography, allowed his galleries to function as 'laboratory centers' where American and European art and photography could be presented with purity, and his artists could freely exchange ideas, helping to define their aesthetic positions.

By the late 1920s, Norman had become part of Stieglitz's inner circle, assisting in managing his gallery, and maintaining relationships with his artists and audience. The activity at The Intimate Gallery flourished, and Stieglitz's dependence on Norman became more pronounced. Simultaneously, Stieglitz's influence on Norman's writings, and eventually on her photography, became more acute as he became the force that unified her various aspirations. As she wrote in *Alfred Stieglitz: Introduction to An American Seer,* "I began to take down Stieglitz's words, which moved me greatly, even before I saw his photographs."

Dorothy Norman was not unacquainted with photography when she met Alfred Stieglitz. At an early age, her parents bought her a Kodak Brownie to take snapshots at school and summer camp. Her casual interest continued and in the early 1920s she acquired a more advanced Kodak camera. Although her enthusiasm for photography grew, she never professed any real success with the medium at this time.

In 1929 Stieglitz was informed that the building in which The Intimate Gallery was located was slated to be demolished. With the support of the painter Georgia O'Keeffe, Stieglitz's wife, and the photographer Paul Strand,

27

Norman was able to persuade Stieglitz to open another
gallery. Their efforts led to the establishment of what was to
become Stieglitz's third and last gallery, An American Place,
located at 509 Madison Avenue. At An American Place,
the number of artists exhibited was much more selective, and
less European. The primary group included Arthur Dove,
John Marin, and Georgia O'Keeffe. In addition, 'The Place,' as
it was referred to by his faithful followers, also exhibited the
works of Charles Demuth, George Grosz, Marsden Hartley,
Rebecca Strand, Helen Torr, and the photographs of Ansel
Adams, Paul Strand, and Eliot Porter.

In 1930, a year after opening An American
Place, Stieglitz began making a series of portraits of Dorothy
Norman that continued through 1937. Unlike the monumental
and often austere portraits he made of Georgia O'Keeffe
from 1916 through the late 1930s, the portraits of Norman
tended to be closer and softer and were rarely enlarged,
generally appearing as a 4-by-5-inch contact print. The tonal
quality of these prints was dramatic, due primarily to the
light-filled interior and the white walls at An American Place.
First shown publicly in a solo exhibition there in 1932, these
portraits confirmed to many that although Stieglitz's marriage
to O'Keeffe was still vital, Norman had acquired a special
place in his life.

28

In front of the camera, Norman became
Stieglitz's willing subject, but she was also a keen observer and
carefully studied his techniques. It is often said that Stieglitz
never had any students nor did he want to be considered a
teacher in the formal sense. However, he supported and
encouraged Norman's growing enthusiasm for making
photographs. To this end, he lent her a 4-by-5-inch Graflex
camera in the spring of 1931 and instructed her in its use.
The Graflex proved too heavy and awkward so Stieglitz
suggested a smaller model that produced a 3 $1/4$-by-4$1/4$-inch
negative; Norman acquired one later that same year.

 An American Place contained a darkroom
where Stieglitz offered to process Norman's film and make
prints from the negatives until she was able to work in
the darkroom on her own. Although Stieglitz held no formal
classes, he outlined the basics of the photographic process.
They spent hours in the darkroom together, she watching
him, and he overseeing her, offering advice and
encouragement.

 On the backs of her prints Stieglitz often
wrote elaborate instructions for the correction of exposures,
along with glowing praise when he saw what he called a
'wonderfully felt' vision. Frequently, Stieglitz would end his

29

notations on the prints with the initials I L Y (I Love You) or I B O (I Bow Out). I B O meant he felt his pupil needed no further assistance with a particular problem, and he bowed to her success.

The earliest photographs Norman made were portraits of Stieglitz and others close to her, and images made during her summers on Cape Cod. The four primary subject areas appearing in these early photographs (portraits, nature, architecture, and manmade objects) became recurring themes throughout her relationship with photography.

On rare occasions she made multiple exposures in her camera on a single sheet of film, but her photographs were predominantly characterized by their unmanipulated technique acquired from Stieglitz. The deep, rich tones of her print quality are proof of what she learned from Stieglitz's and Strand's prints.

The 1930s through the mid-1950s proved to be Norman's most active years in photography. Her contact with the artists and patrons of An American Place, her involvement with various social, political, and international groups, and her interest in the performing arts account for the great variety of personalities who appear

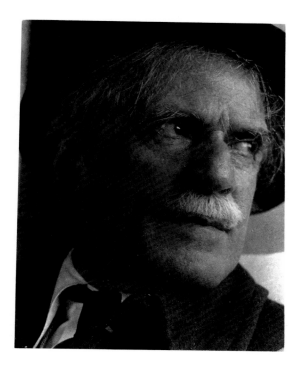

Alfred Stieglitz, 1931

in her portraits from this time. It was their social and cultural aspirations that made them the focus of Norman's camera.

Her summer home in Woods Hole on Cape Cod became the arena where Norman's photographs of nature were recorded. These images show Norman's attraction and reverence for the subject. They also served as a diversion from New York, the worsening situation in Europe, and anxieties caused by marital problems.

The architecture of New York City was also a focus for Norman during the 1930s. Both Stieglitz and she photographed the changing cityscape through the windows of An American Place. Her images of New York, more abstract in manner than her portraits, were responses to the changing balance of light filtering down through the city's caverns. The photographs she made at this time addressed how the new structures of this era would exist with the old, and if it was indeed possible for them to coexist at all.

The sudden death of Alfred Stieglitz in July of 1946 had a profound effect on Norman. Compounded by the deaths of Paul Rosenfeld, Theodore Dreiser, Gertrude Stein, her close friends and associates who died shortly after Stieglitz, Norman found herself alone. Stieglitz's death signaled a new resolve for Norman, one reinforced by her

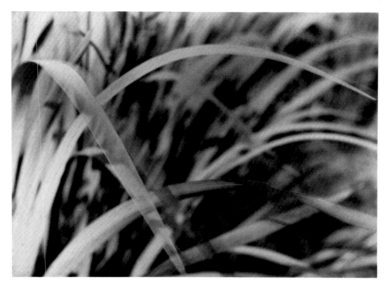

Lovely Lovely Lovely
Very different kind of feeling
than the other — Just as
beautiful — just as intense —
terrifically sensitive &
delicate — but very positive —
Yor

IBO

Woods Hole, c. 1931–1932
A. S. notation on verso of this photograph

33

deeply-rooted interests in modern and primitive art, and contemporary writing. Freed from the everyday concerns of overseeing the affairs of An American Place, which closed after Stieglitz's death, she was able to focus her energies on a few select projects. The post-World War II years heightened Norman's concern for the resettling of Europe and for the loud demands for freedom being heard in India and other colonies in the Middle East and Asia.

Her involvement in the various groups that supported the independence of India led to her introduction to Jawaharlal Nehru during his first trip to the United States in 1949. Unlike the circumstances of her meeting with Stieglitz, unknowing of his great reputation, Norman had admired Nehru for years. He embodied the spiritual essence and promoted the democratic values she worked toward in years of writing, publishing and photography. Norman also befriended Nehru's daughter, Indira Gandhi, who became a close friend and confidant until her death in 1984. Similar to her years with Stieglitz, Norman was once again in the company of remarkable figures whose beliefs she shared.

In 1950, Norman began making frequent trips to Europe, India, the Middle East, and Asia. These

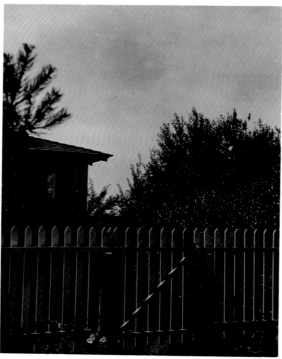

*I can see you
there. The gate —
the little flowers
down below — all
you so much. — Very good*

Cross Street House, Woods Hole, c. 1931–1932
A.S. notation on verso

trips, filled with the opportunity to photograph spiritual, cultural, and political events, prompted the need for a reassessment of her photographic equipment. The 3 $^1/_4$-by- 4$^1/_4$-inch Graflex finally proved to be too cumbersome. The advances in smaller, roll-film cameras, improved lenses, and the increased speed and variety of available film convinced her to convert to a Rolleiflex 2 $^1/_4$-by-2$^1/_4$-inch camera. The Rolleiflex was portable and retained the quality of the lens-to-film proportion of the Graflex, but didn't require weighty film holders.

Norman relished the mobility her new camera allowed. At first she tried to mimic the style of the Graflex, but soon she realized that the camera's portability granted her new creative license. Her photographs made with this camera demonstrate a more casual, relaxed vision. She never returned to large-format cameras; the Rolleiflex continued to be her trusted companion for the balance of her photographic career.

The late 1950s were Norman's last active years in photography. Due to failing eyesight, she stopped making photographs for the most part. There were a few exceptions — portraits of close friends and family members, and images made in Mexico during the 1960s

and early 1970s. Photography was not Norman's vocation. Her primary contributions were writing, editing, and reporting. She never considered herself a professional photographer as her contemporaries Berenice Abbott, Margaret Bourke-White, Louise Dahl-Wolff, Lee Miller, and Marion Post Wolcott were. Her motivations were purely personal. Since Norman needed neither the exposure nor income, her work remained overlooked for many years.

Norman leaves as a legacy to photography her eloquent writings on the life and importance of Alfred Stieglitz and a body of photographs revealing her intimate feelings about the subjects before her camera. There is an economy to her vision. Her prints ultimately show what she felt was most important, without superfluous detail or visual editorial comment. They are simple, clean, and true to the spirit of humanity.

37

verso Alfred Stieglitz
1931
(opposite page)

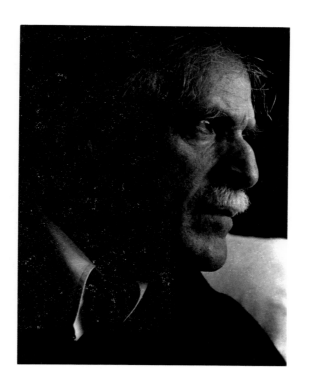

Alfred Stieglitz
1931

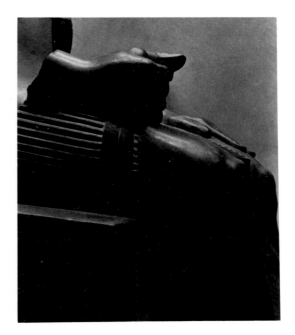

40

Statue of King Mycerinus (detail)
Museum of Fine Arts, Boston
c. 1931–1932

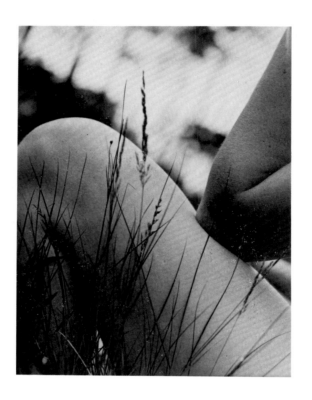

41

Catherine Bauer
Woods Hole
c. 1932

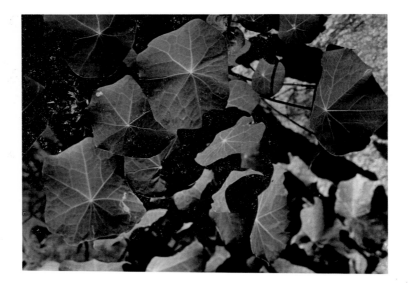

42

Leaves
Woods Hole
1931

Sky
c. 1931

As for Stieglitz it is as if he saw, and felt, the most fleeting moments of the most fragile and angelic delicacy, perfectly merged with the most deep-rooted, eternal, timeless surges of man's relationship with all things in the universe. His work is of the deep sound in the center of the earth, whispered on wings in the sky. In Stieglitz's photographs you find the finely chiseled white circle, like a tiny Holy Grail, and all around and integrally attached are all of the other values of light and dark, of aspiration, of fulfillment, of despair, of tragedy, of deepest love and darkest hate, of brightest good and most destructive evil — of deep mass and delicate tracery — all in the proportion of the way you feel it when you are most alive, which means having an experience that is most 'tragically' fulfilling.

All of Stieglitz's pictures relate back always to the inner aspiration or spiritual struggle of man.

The word 'art' somehow separates abstraction from the concrete business of living, and this infuriated Stieglitz. That is why he so often says that his life has been devoted to doing away with labels. That is why he is always challenging people to see, to feel, to do without labels, without props, before any phenomenon. And he knows if one could tell what life is, art is, love is, the things themselves would disappear. And he will not put *An American Place* in the phone book or list it as a gallery. He feels that if people really need a thing they will find it. And when there is no pressing need, no inner urge, there will be no finding.

— from a letter to Henry Miller, February 15, 1940

Alfred Stieglitz
(first portrait taken by D.N.)
1931

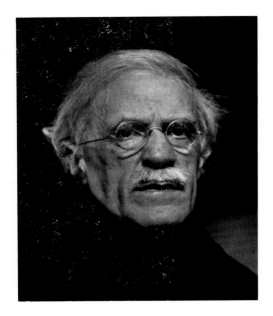

Alfred Stieglitz
1932

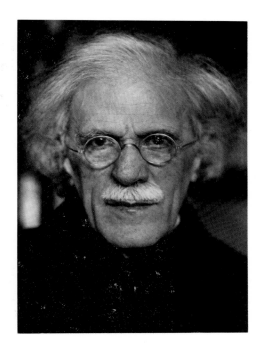

Alfred Stieglitz
1934

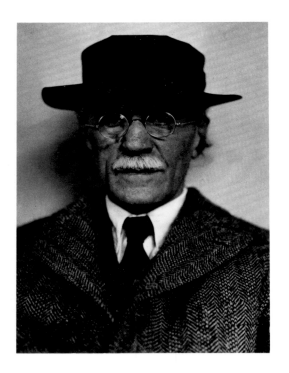

48

Alfred Stieglitz
ICP Permanent Collection
1933

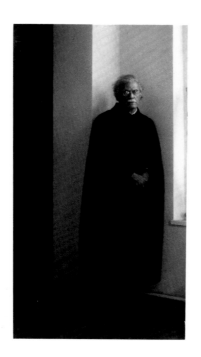

Alfred Stieglitz
1934

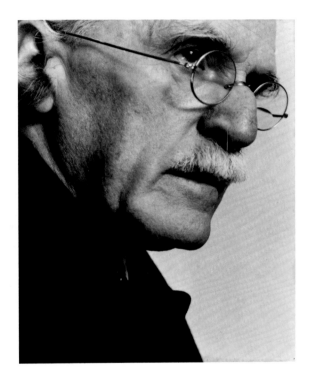

50

Alfred Stieglitz
1934

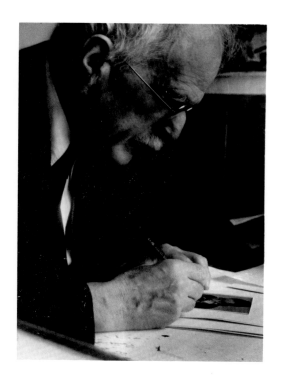

51

Alfred Stieglitz
(spotting his portrait of Dorothy Norman)
1933

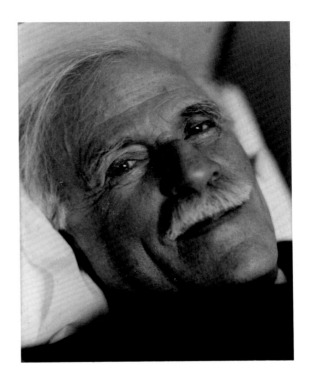

52

Alfred Stieglitz
1944

53

Alfred Stieglitz
1935

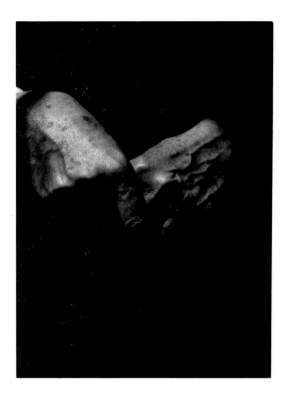

54

Alfred Stieglitz
1935

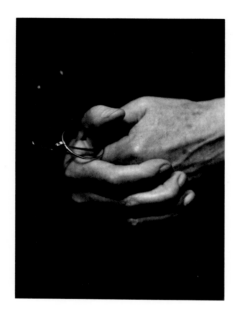

Alfred Stieglitz
1935

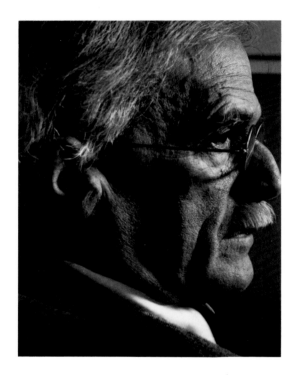

56

Alfred Stieglitz
ICP Permanent Collection
1934

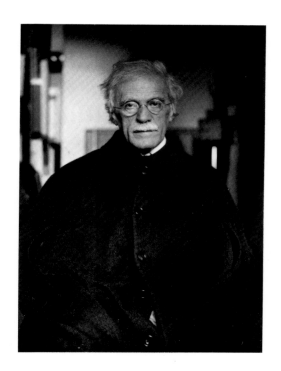

Alfred Stieglitz
1934

58

Alfred Stieglitz
1933

59

Alfred Stieglitz
Collection of Nancy Wu
1936

60

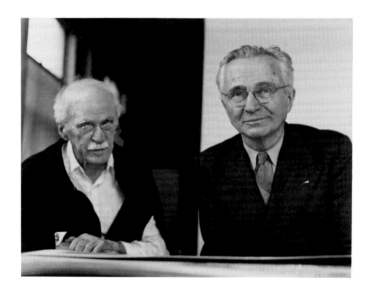

Stieglitz and Edward Steichen
1946

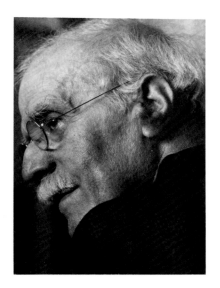

Alfred Stieglitz
(last portrait D.N. made of him)
1946

As I became more and more closely associated with Stieglitz's final 'laboratory center,' *An American Place*, I decided to keep a record of what I experienced there so that I might share it. I did what I could on behalf of the artists Stieglitz championed, but it was Stieglitz's own work I treasured the most. His photographs for me were the most original, awe-inspiring *American* art of the period.

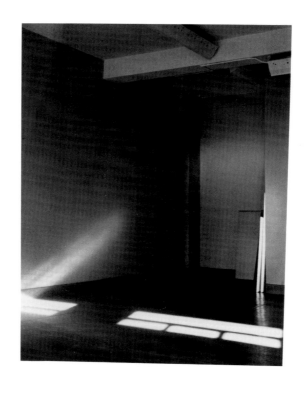

63

Walls (After Stieglitz's Death)
An American Place
1946

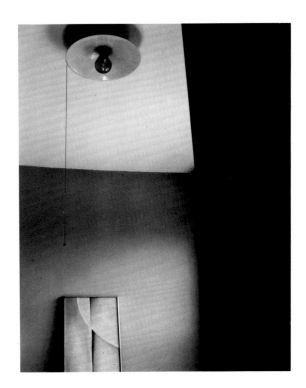

64

Georgia O'Keeffe Painting with Light Bulb
c. 1936

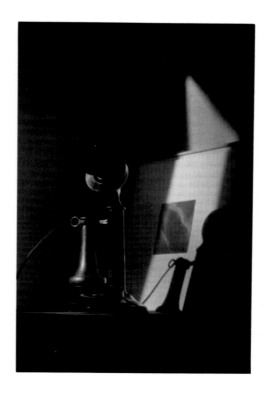

65

Telephone in Front of Stieglitz *Equivalent*
ICP Permanent Collection
c. 1940

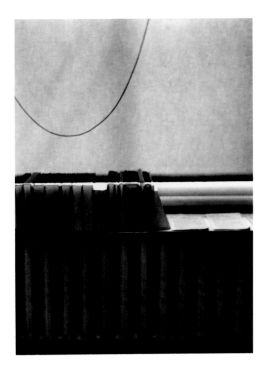

66

Twice A Year on Radiator, Main Gallery
c. 1945

67

Opening Between Two Galleries
c. 1935

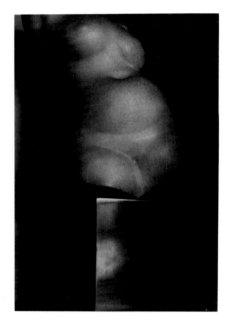

Torso by Gaston Lachaise
1946

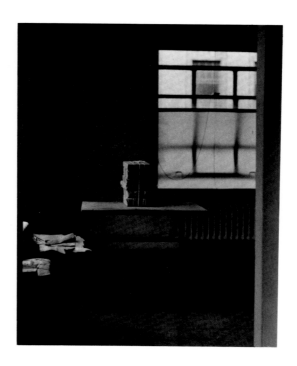

Packages of *Twice A Year* Ready to Mail
c. 1945

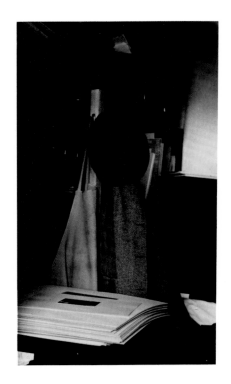

Stieglitz's Hat and Coat in Vault
c. 1940

Autumn
Lake George
1947

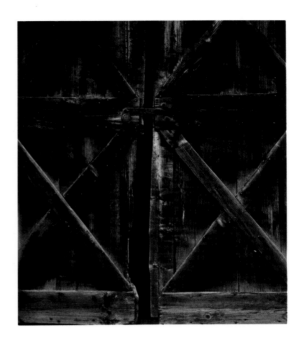

Barn Doors
Lake George
1947

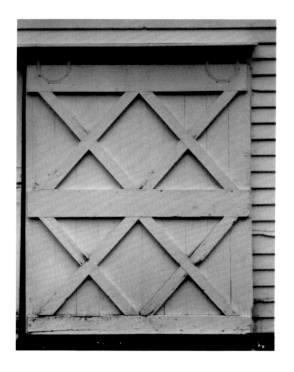

73

Barn Door
Lake George
1947

I loved to photograph certain faces. When I took portraits I wanted most of all to make close-ups that showed as much as possible of the face. Its expressiveness must come through in order to illuminate character.

Edward Norman
1932

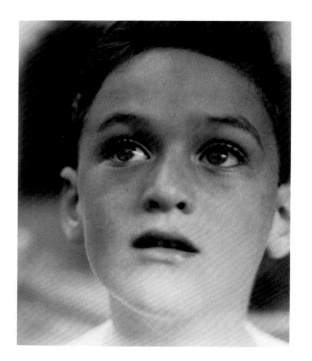

76

Andrew Norman
Philadelphia Museum of Art:
From the Collection of Dorothy Norman
1932

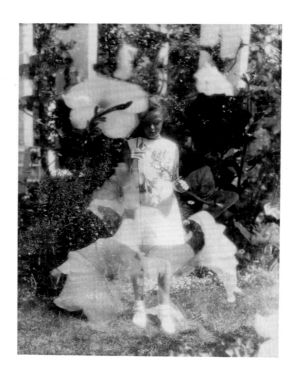

Nancy Norman and Flowers
(double exposure made in camera)
1933

78

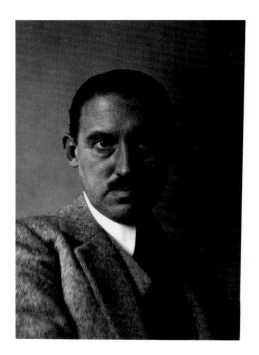

Charles Demuth
1932

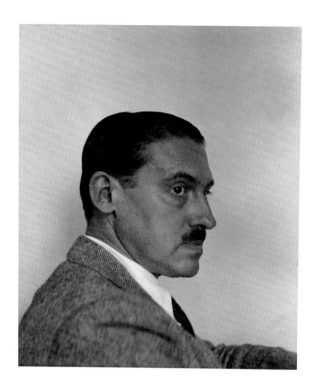

Charles Demuth
1932

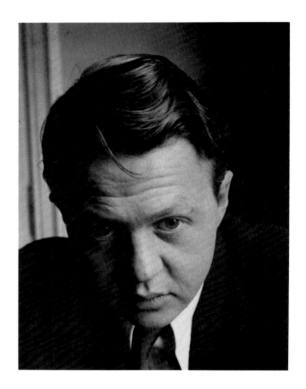

80

Gerald Sykes
1932

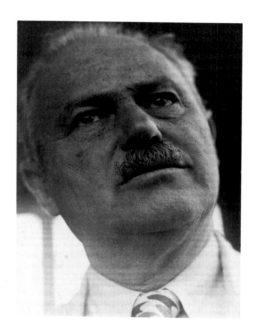

81

Waldo Frank
1934

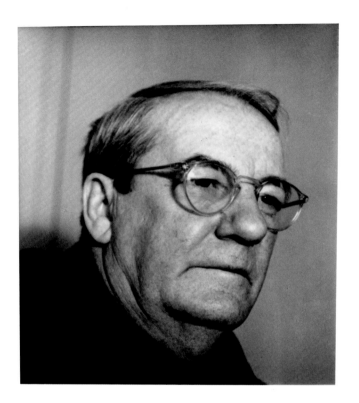

82

Sherwood Anderson
1935

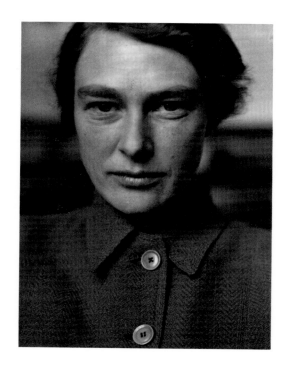

Beatrice Lamb
c. 1936

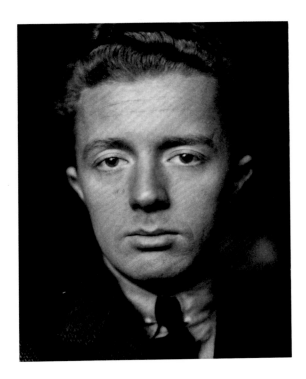

Paul Bowles
1936

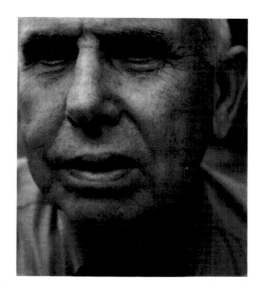

Theodore Dreiser
1937

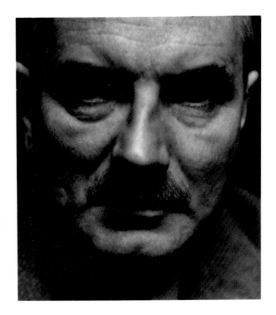

Lewis Mumford
c. 1940

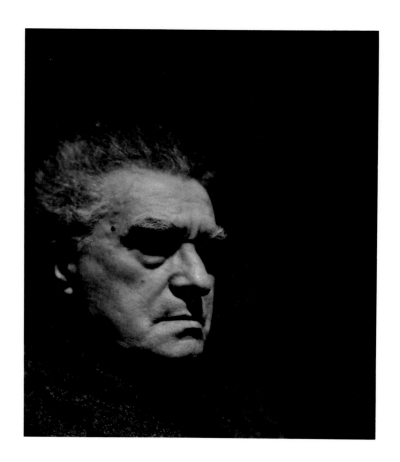

Edgard Varese
c. 1940

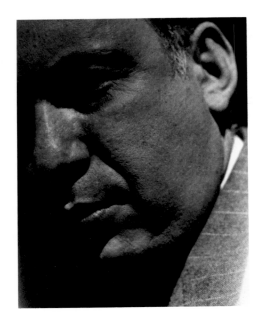

Harold Clurman
1942

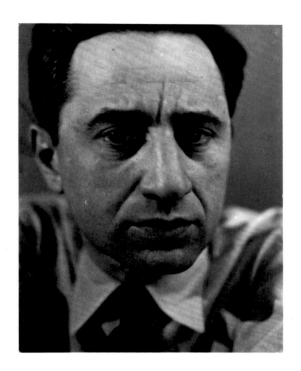

Elia Kazan
1942

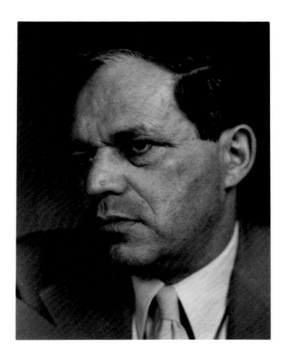

Louis Fischer
1942

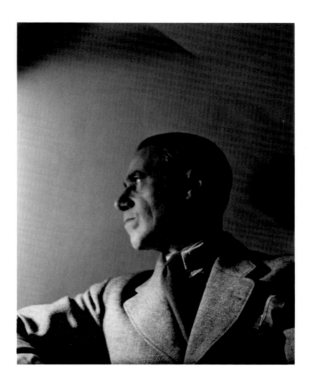

Hans Richter
c. 1942

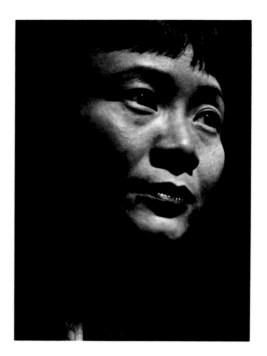

92

Mai-Mai Sze
1943

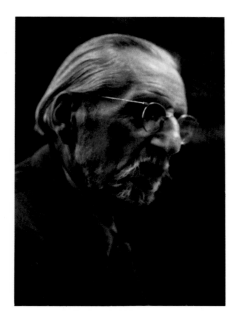

Ananda K. Coomaraswamy
1947

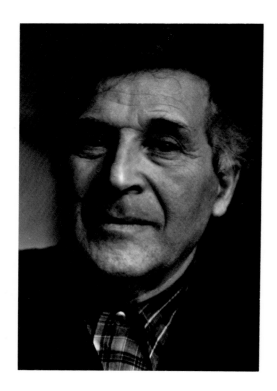

94

Marc Chagall
1944

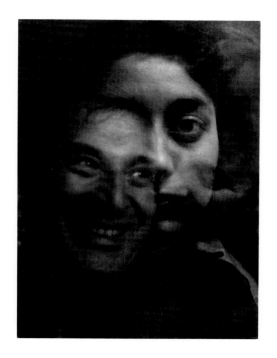

Marc Chagall, Ida Chagall, and Rita Pandit
(multiple exposure made in camera)
1944

John Marin
1944

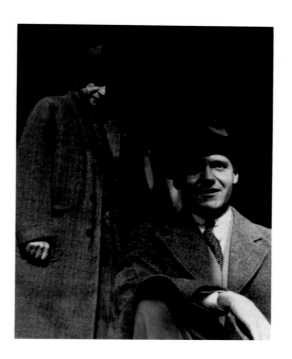

John Marin, Sr. and Jr.
Philadelphia Museum of Art:
From the Collection of Dorothy Norman
1946

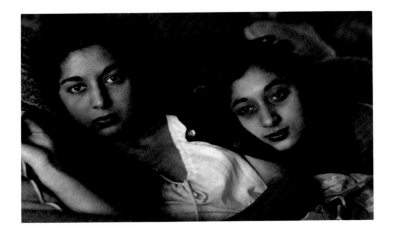

Tara and Rita Pandit
1945

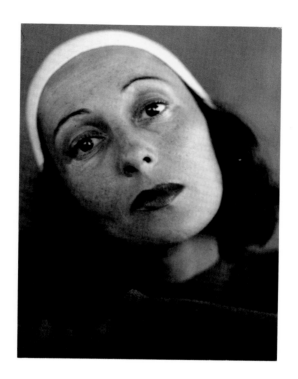

99

Luise Rainer
1945

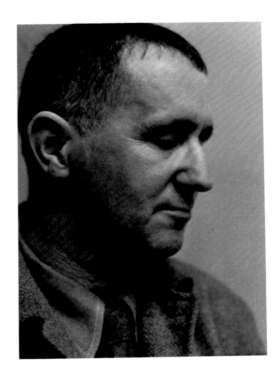

100

Bertolt Brecht
1945

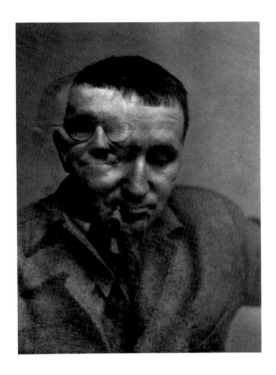

Bertolt Brecht
(double exposure made in camera)
1945

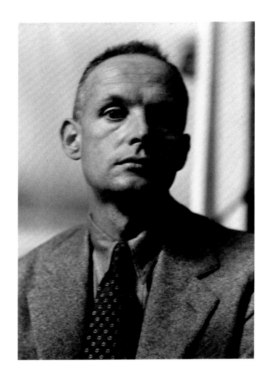

Henri Cartier-Bresson
1946

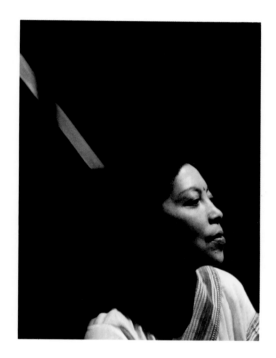

Elli Cartier-Bresson
1946

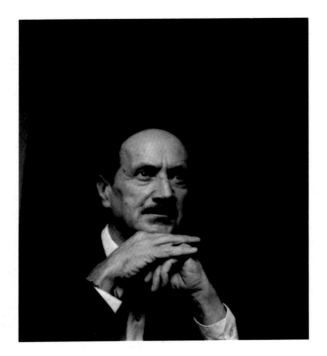

104

St.-John Perse
1950

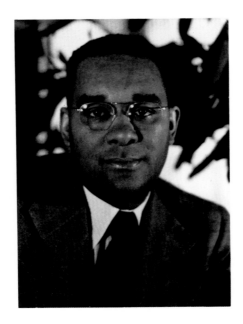

Richard Wright
1946

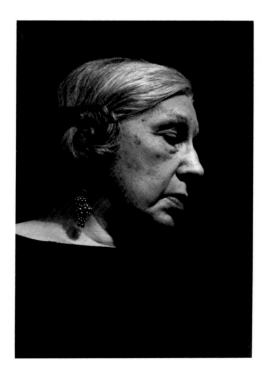

106

Mme. Gaston Lachaise
1947

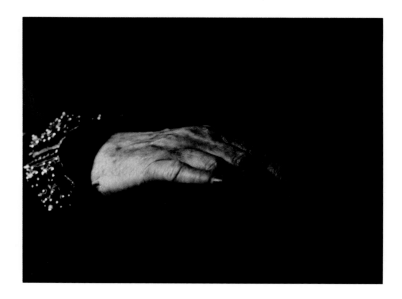

Mme. Gaston Lachaise
1947

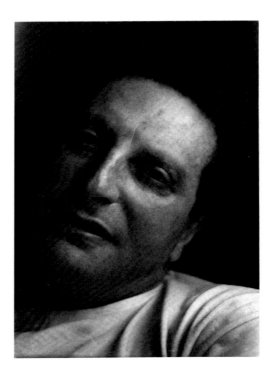

108

Carlo Levi
1947

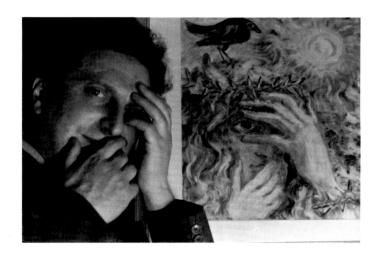

Carlo Levi
1947

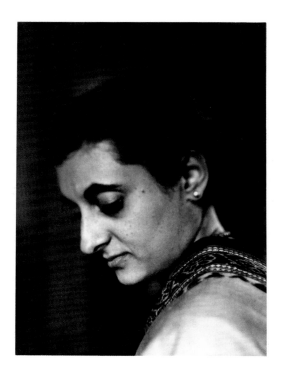

110

Indira Gandhi
1949

Indira Gandhi
1949

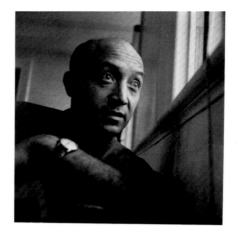

112

Isamu Noguchi
1957

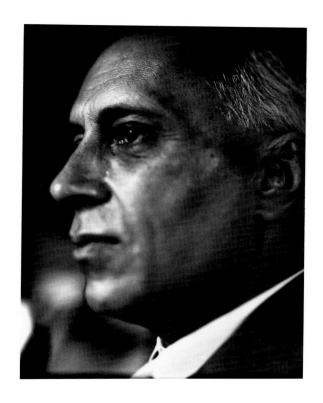

Jawaharlal Nehru
1949

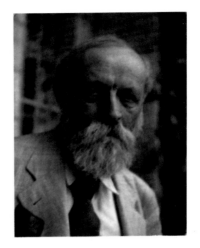

Martin Buber
1950

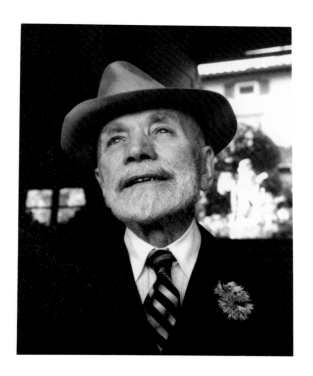

Bernard Berenson
1950

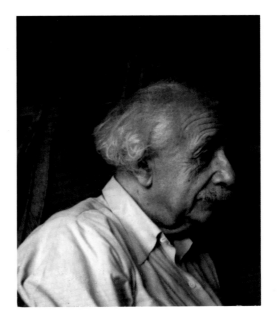

Albert Einstein
1952

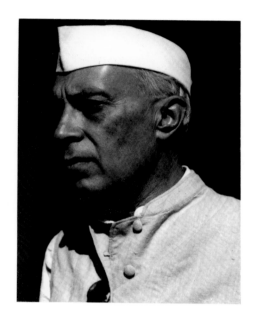

Jawaharlal Nehru
1952

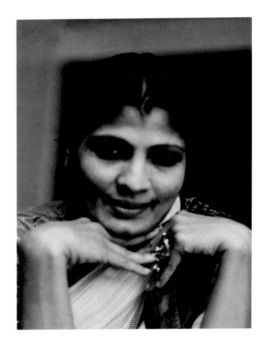

118

Shanta Rao
c. 1953

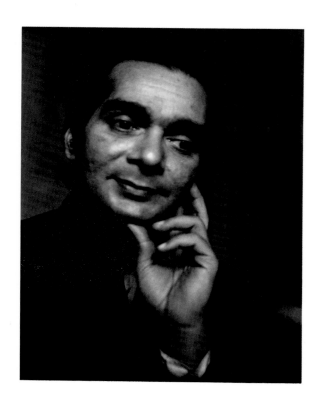

119

Uday Shankar
c. 1953

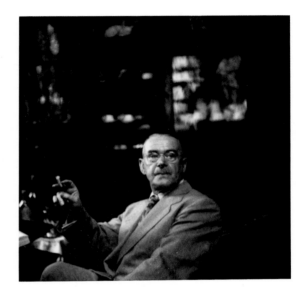

120

Thomas Mann
1954

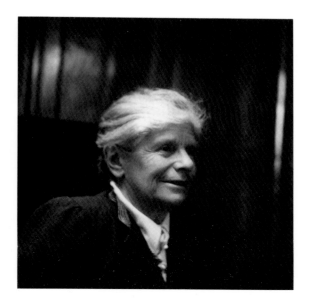

Katia Mann
1954

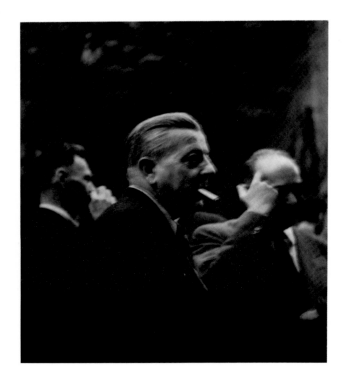

122

Jacques Prevert
1954

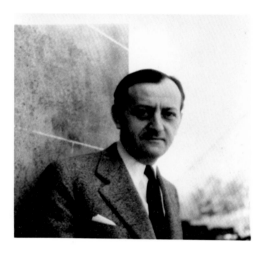

André Malraux
1954

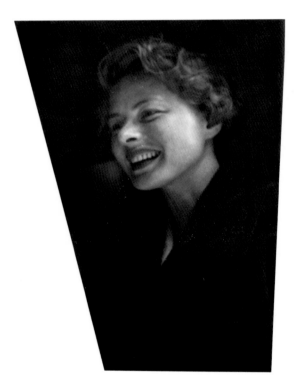

Ingrid Bergman
1954

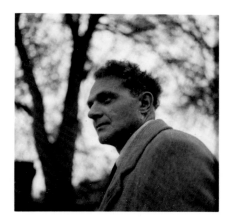

Stephen Spender
1954

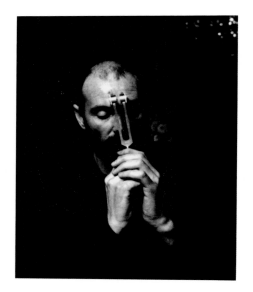

126

Morris Graves
1955

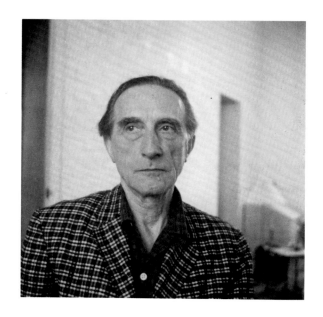

Marcel Duchamp
1956

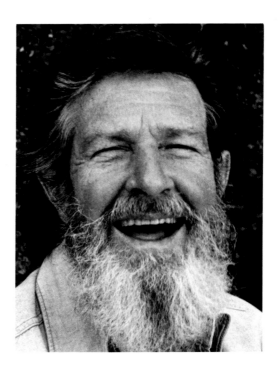

128

John Cage
1972

I came to New York from Philadelphia at the age of twenty.
New York overwhelmed me with its myriad buildings. The
relationship of churches to skyscrapers moved me, as did
the sun creeping up the sides of enormous buildings that were
otherwise simply sheets of building material. The architecture
of New York demanded purity, then suddenly in the late
Forties a kind of toy pseudo-skyscraper overtook the city, and
I couldn't photograph any of it anymore.

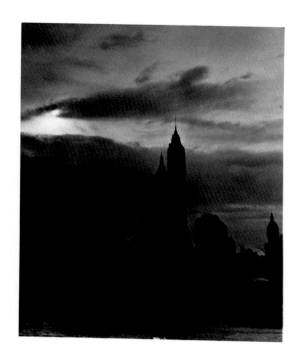

New York Skyline
1942

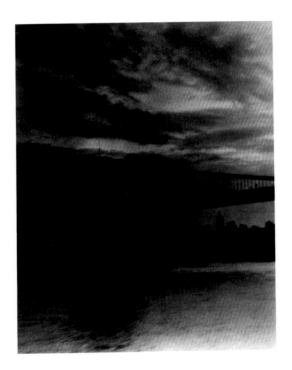

132

Brooklyn Bridge from the Boat to New Bedford
Philadephia Museum of Art:
From the Collection of Dorothy Norman
1932

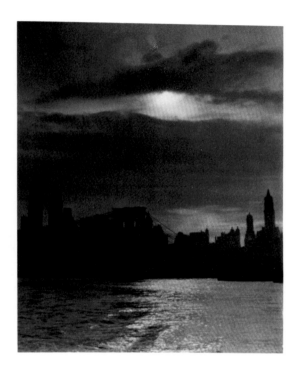

133

New York from Boat to New Bedford
Philadephia Museum of Art:
From the Collection of Dorothy Norman
1932

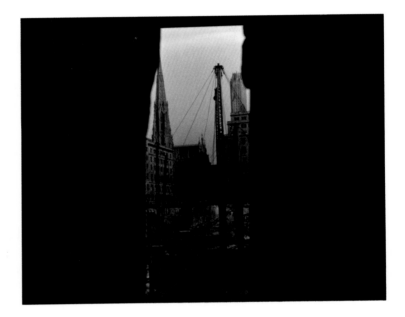

Church and Crane
1932

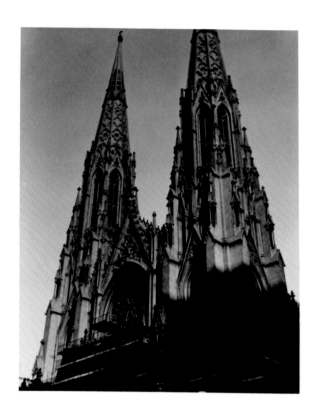

135

St. Patrick's Cathedral
1932

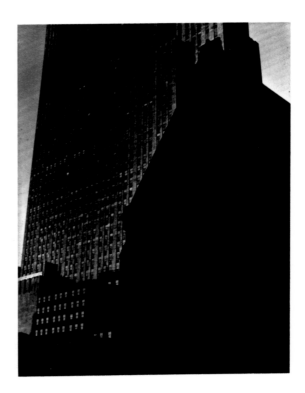

136

Rockefeller Center and Church
1932

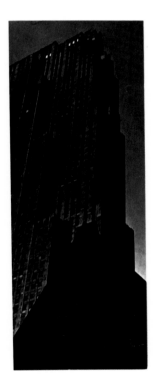

Rockefeller Center
1932

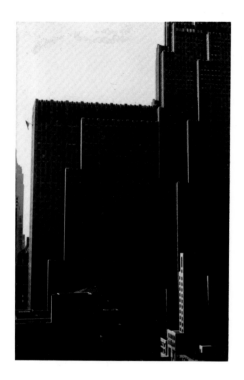

138

Rockefeller Center
1938

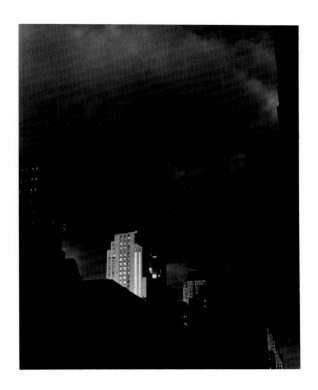

139

New York from 53rd and Madison
1933

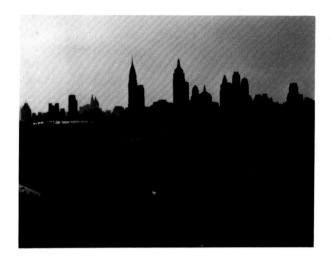

140

New York Skyline
Collection of Asa Ivry
1942

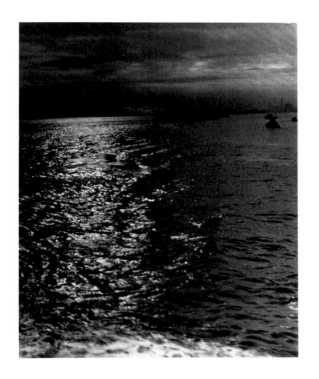

141

New York Harbor
1932

The weathervanes and lighthouses on Cape Cod were shining beacons. The feeling of sunlight on white has always excited me. I watched the gravestones — the carvings on them would be etched with a singular clarity. I photographed them with loving care.

But most of all I loved the churches. A perfect church spire, made simply, with integrity, reaching up to heaven, neither asks anything of heaven in response to itself nor pretends to have achieved heaven by making a gesture toward it. It merely says to me: This is how we really feel about life. This is our center reaching beyond anything touchable, hence up to the sky.

The pure white form of a steeple ascending over the Cape Cod landscape seemed to me a perfect icon of man's relationship to an ideal that he is ever reaching to touch and surpass. When I took up my camera to record a sharp image in black and white I was elated. The thought that I have communicated the shining spirit of a sun-touched steeple through my photographs still makes me momentarily satisfied.

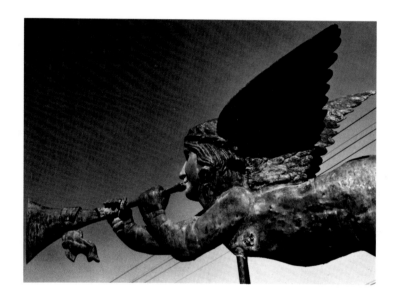

143

Angel Gabriel
Chatham
1937

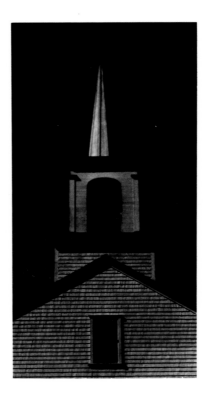

144

Meeting House
East Falmouth
1933

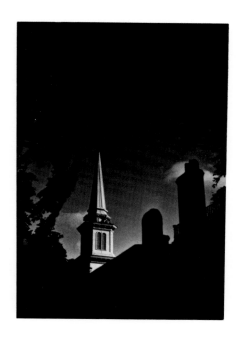

145

Church Steeple
Falmouth
1937

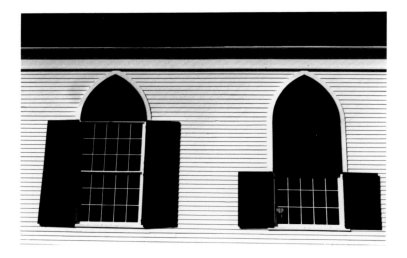

146

Church
Waquoit
1935

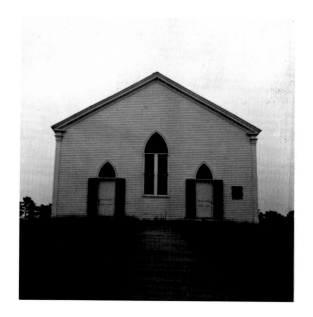

Church
Waquoit
1935

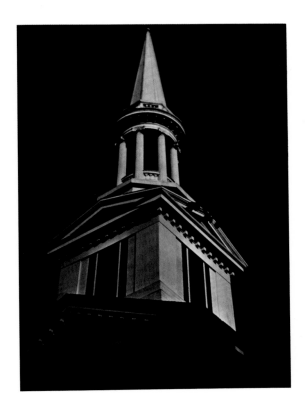

148

Church
Falmouth
1933

149

Church and Flagpole
Falmouth
1934

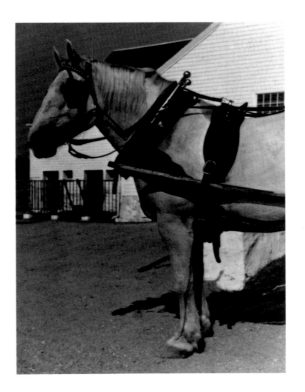

150

Horse
Osterville
Philadelphia Museum of Art:
From the Collection of Dorothy Norman
1937

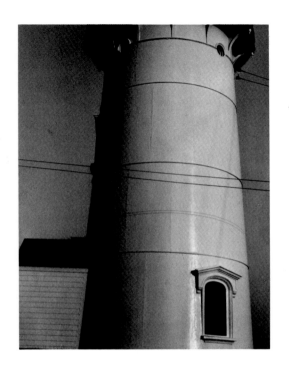

151

Lighthouse
Nobska Point
1937

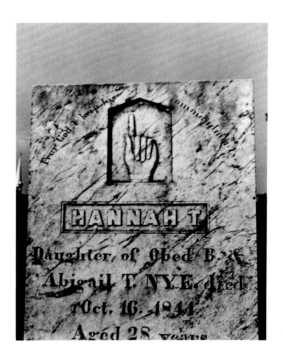

152

Gravestone
Sandwich
1936

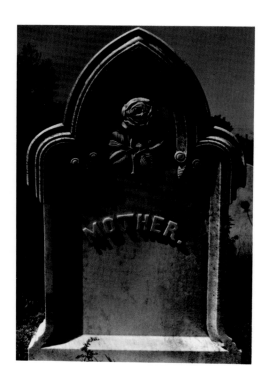

Gravestone
Chatham
1937

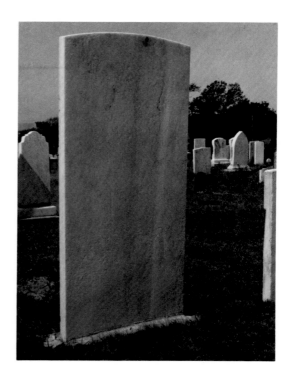

154

Gravestone
Chatham
1937

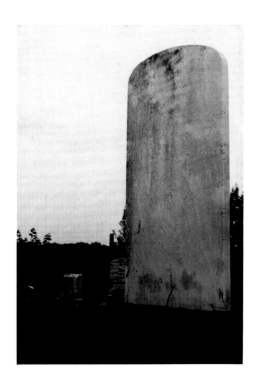

155

Gravestone
Chatham
1937

I would peer into my camera, obsessed by the trembling edge
and texture of white in a petal — sharp, cleansed, with a tinge
of unearthly yellowish green. The veins of gray-white were so
delicate it was hard to imagine they would not vanish. A moon
flower. Petunia. Cosmos. Water lily. Round. The feeling of
white. Flowers that would not stay immobile in the wind. The
wind is quiet for a split second before it blows again. It has
a whirl, then rests. I discovered its timing. No one had told me
about this. During the wind's rest I clicked. Everything was
magically still. Did I catch what I saw? The absence of color in
the prints bothered me for a time, then it didn't.

 The petal behind, beside, was blurred, thin,
almost transparent. The one I concentrated on became sharp.
I shut down my lens, held my breath. I clicked, again and again.
Each moment the light changed. Did I catch anything or not?
I was never certain, but I was transformed.

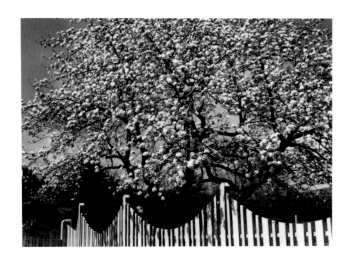

Apple Blossoms
Woodstock
1936

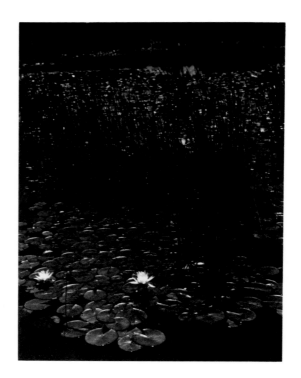

158

Water Lily Pond
Ashumet Farm, Hatchville
1932

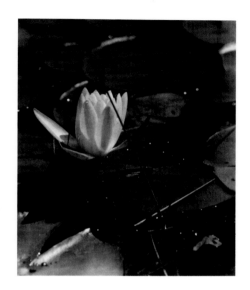

Water Lily
Woods Hole
1936

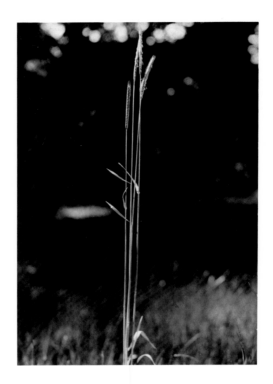

160

Woods Hole
1932

161

Tree
Woods Hole
1932

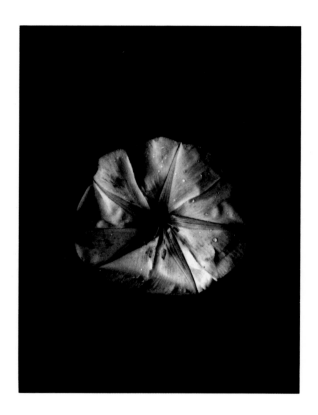

162

Moonflower
Woods Hole
ICP Permanent Collection
1936

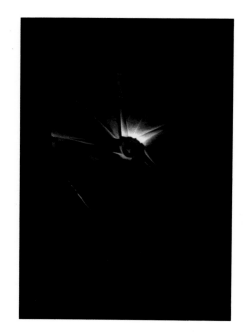

Heavenly Blue Morning Glory
Woods Hole
1936

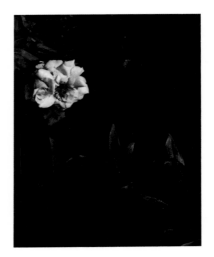

164

Rose
Woods Hole
1936

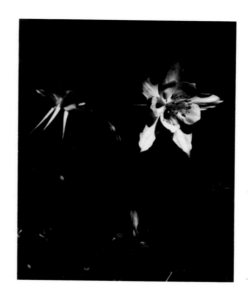

165

Aquilegia
Woods Hole
1934

India struck me with its infinite glories immediately. It was
beautiful but also terrifying. At Sevagram, the village in India
where Gandhi inspired so many, I photographed the pillow on which
he slept — infinitely moving. I gazed with awe at the marvelous
erotic figures adorning the best Indian temples, at the marvels that
Le Corbusier wrought at Chandigarh, and at the many wonders
of Jaipur. I photographed the Sun Temple at Konarak and the women
in the fields. India touched me profoundly.

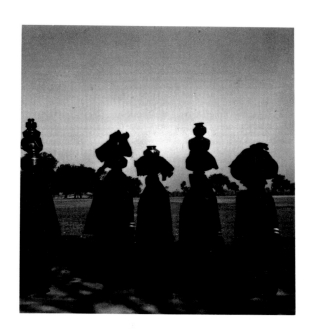

Women in Field
Ragasthan
1950

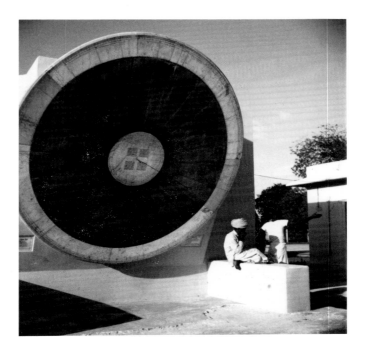

168

Astronomical Form
Jaipur
1959

169

Detail of Le Corbusier Building
Chandigarh
1959

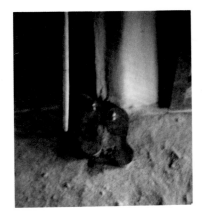

170

Mahatma Gandhi's Sandals
Sevagram
1950

Mahatma Gandhi's Pillow
Sevagram
1950

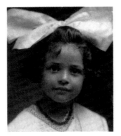

Dorothy Norman
Philadelphia, 1911
photographer unknown

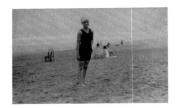

Dorothy Norman
Lido Beach, Venice, Italy, 1926
photographer unknown

1905 Born March 28,
Philadelphia, Pennsylvania,
the third of three children
born to Louis and Ester
Stecker.

1920–1921
Attends Fairmont School,
Washington, D.C., and
Mary C. Wheeler School,
Providence, Rhode Island.

1922–1923
Attends Smith College.

1924–1925
Attends University of
Pennsylvania, Philadelphia.

1924 Meets Edward Norman.
Among first group of
college students to take art
history classes at the Barnes
Foundation, Merion,
Pennsylvania.

1925 Marries Edward Norman,
June 10. Moves to New
York City; does research for
the American Civil Liberties
Union and becomes a
member of the Board of
Directors of the New York
Urban League.

1926 Attends the International
Consumers Cooperative
Summer School in
Manchester, England, and
tours Europe. Serves on
committees of Women's
City Club of New York.
First visit to The Intimate
Gallery, which Alfred
Stieglitz opened in 1925.
On a subsequent visit
that same year, Stieglitz
shows Norman his
photographs, and those
of Paul Strand.

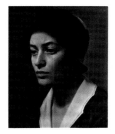

Dorothy Norman, 1930
photograph by Alfred Stieglitz

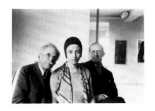

Alfred Stieglitz, Dorothy Norman, and
Marsden Hartley, 1931
photographer unknown

1927 Begins close association
with Stieglitz. Reads
Camera Work and 291 for
first time. Begins to
spend summers at Woods
Hole, Cape Cod. Birth of
daughter, Nancy. Works
with Margaret Sanger in
her Birth Control League.

1928 Writes article on Stieglitz
which later evolves into a
book, *Alfred Stieglitz: An
American Seer*. Acquires
Woman, a bronze by Gaston
Lachaise, at The Intimate
Gallery. Meets Ananda
Coomaraswamy, eminent
Indian scholar, in Boston.

1929 Assists Stieglitz in the
closing of The Intimate
Gallery. With Paul Strand
and Georgia O'Keeffe
raises funds for creation of
An American Place.

1930 Birth of her second child,
Andrew. Stieglitz makes his
first portraits of Norman.

1931 Receives the loan of a
4-by-5-inch Graflex
camera from Stieglitz and
begins to photograph. Later
acquires a more mobile
$3^1/_4$-by-$4^1/_4$-inch model
which she continues to use
until the late 1940s.

1932 Stieglitz's portraits of
Dorothy Norman are first
exhibited in a retrospective
of his work at An American
Place.

1933 *Dualities*, her volume of
poems, published by Stieglitz
at An American Place.

1934 Co-edits and contributes
to *America and Alfred Stieglitz* to
celebrate his 70th birthday.

173

Dorothy Norman, 1931
photograph by Alfred Stieglitz

Dorothy Norman, 1937
photograph by Alfred Stieglitz

1938 Publishes and edits
*Twice A Year: A Semi-Annual
Journal of Literature, the Arts and
Civil Liberties* until 1948.

1941 Joins the Board of
Directors of Union for
Democratic Action
and for the India League
of America. The Normans
remodel a home on
East 70th Street in New
York City and have it
designed by William
Lescaze.

1942 Writes "A World to Live
In," a column for the *New
York Post*, three times a
week until 1949. Takes
active interest in New York
City politics and in 1944
becomes a director of
newly established Liberal
Party.

1946 Alfred Stieglitz dies.
Norman helps in closing
An American Place.

1949 Writes introduction
and edits *Selected Writings
of John Marin*. Meets
Jawaharlal Nehru, Prime
Minister of India, on his
first visit to the United
States. Participates in
political and social events
in his honor.

1950 Attends the celebrations
of the founding of the
Republic of India by
invitation of Jawaharlal
Nehru. Stays at the Prime
Minister's residence in
New Delhi and becomes
a close friend of his
daughter, Indira Gandhi.
On return to America,
founds and becomes
chairman of Committee
for Aid to India, and also
the Citizens' Committees
to Aid Countries of the
Third World.

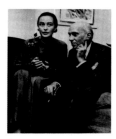

Dorothy Norman and Jawaharlal Nehru
New York, 1949
photograph by Martha Holmes

Dorothy Norman
New York, 1975
photograph by Arnold Newman

1955 Chooses the captions for
"The Family of Man," an
exhibition of photography
at the Museum of Modern
Art, at the invitation of
Edward Steichen.

1958 Creates "The Heroic
Encounter," an exhibi-
tion of symbolic art,
which opened at the
Willard Gallery in New
York, and subsequently
is toured by the American
Federation of Art.

1960 Writes the monograph,
*Alfred Stieglitz: Introduction to
an American Seer*, for *Aperture*,
a quarterly magazine
edited by Minor White.
Published as a book by
Duell, Sloan & Pearce,
New York.

1968 Establishes Alfred Stieglitz
Center at the Philadelphia
Museum of Art and gives the
museum a collection of
photographs by Stieglitz and
other photographers.

1969 Publication of her book,
The Hero: Myth/Image/Symbol.

1973 Publication of her book,
Alfred Stieglitz: An American Seer.

1987 Publication of her book,
Encounters—A Memoir.

175

Sherwood Anderson
Author
New York

Bernard Berenson
Author, expert on
Italian painting
Florence

Ingrid Bergman
Actress
Rome

Paul Bowles
Composer, author
New York

Bertolt Brecht
Playwright
New York

Martin Buber
Philosopher, author
Israel

John Cage
Composer, author
Cuernavaca, Mexico

Henri Cartier-Bresson
Photographer
New York

Elli Cartier-Bresson
Dancer
New York

Ida Chagall
Daughter of Marc Chagall
New York

Marc Chagall
Artist
New York

Harold Clurman
Founder, Group Theater;
stage director; critic
New York

Ananda K. Coomaraswamy
Author, interpreter of
Indian art and tradition
Boston

Charles Demuth
Artist
New York

Theodore Dreiser
Author
Woods Hole, Massachusetts

Marcel Duchamp
Artist
New York

Albert Einstein
Physicist, author
Princeton, New Jersey

Louis Fischer
Author
New York

Waldo Frank
Author, editor, critic
New York

Indira Gandhi
Prime Minister of India
New York

Morris Graves
Artist
New York

Elia Kazan
Theater and film director
New York

Mme. Isabel Lachaise
Wife of sculptor,
Gaston Lachaise
New York

Beatrice Lamb
Author
New York

Carlo Levi
Author, painter
New York

André Malraux
Author
Paris

John Marin
Artist
Cliffside, New Jersey

Katia Mann
Author
Paris

Thomas Mann
Author
Paris

Lewis Mumford
Author, critic
New York

Jawaharlal Nehru
First Prime Minister
of India, author
New York and New Delhi

Isamu Noguchi
Sculptor
East Hampton

Andrew Norman
Son of the photographer
Woods Hole

Edward Norman
Economist, husband of
the photographer
Woods Hole

Nancy Norman
Daughter of the photographer
Woods Hole

177

Tara and Rita Pandit
Daughters of V.L. Pandit,
Indian Ambassador to the U.S.
Woods Hole

St.-John Perse
Poet
Washington, D.C.

Jacques Prevert
Author
Paris

Luise Rainer
Actress
Woods Hole

Shanta Rao
Traditional Indian dancer
New York

Hans Richter
Film producer
New York

Uday Shankar
Traditional Indian dancer
New York

Stephen Spender
Author, poet
London

Gerald Sykes
Author
New York

Mai-Mai Sze
Author, artist
New York

Edgard Varese
Composer
New York

Richard Wright
Author
New York

PUBLISHED WORKS OF DOROTHY NORMAN

Author

Dualities. New York: An American Place, 1933.

The Heroic Encounter. New York: Grove Press, 1958.

Alfred Stieglitz: Introduction to an American Seer. New York: Duell, Sloan & Pearce, 1960.

The Hero: Myth/Image/Symbol. New York: World Publishing Co., New American Library, 1969.

Alfred Stieglitz: An American Seer. New York: Random House, 1973.

Encounters — A Memoir. New York: Harcourt, Brace, Jovanovich, 1987.

Editor

America and Alfred Stieglitz (co-editor). New York: Doubleday, Doran and Co., 1934.

Selected Writings of John Marin. New York: Pellegrini and Cudahy, 1949.

Jawaharlal Nehru, The First Sixty Years, Vols. I & II. New York: John Day & Co., 1965.

Indira Gandhi: Letters to an American Friend. New York: Harcourt, Brace, Jovanovich, 1985.

Editor and Publisher

Twice A Year: A Semi-Annual Journal of Literature, the Arts and Civil Liberties. New York: Dorothy Norman, 1938–1948.

Stieglitz Memorial Portfolio. New York: Dorothy Norman, 1947.

Columnist

"A World to Live In." New York Post. 1942–1949.

The photographic reproductions in this publication were made
from original gelatin silver prints made by Dorothy Norman and are
reproduced actual size. The photographs were selected from the
photographer's personal archive with the exceptions of loans from
the Philadelphia Museum of Art: From the Collection of Dorothy
Norman, The Alfred Stieglitz Collection at the National Gallery of Art,
Washington, D.C., the International Center of Photography, New
York, the Howard Greenberg Gallery, New York, Nancy Wu, Asa
Ivry, and Arnold Newman.

This book was designed by Sheila Levrant de Bretteville with
Susan Sellers at the Sheila Studio, New Haven, Connecticut. The text
was set in Gill Sans Light and Joanna designed by Eric Gill in 1928
and 1931. The book was printed by Toppan Printing Company, Japan.

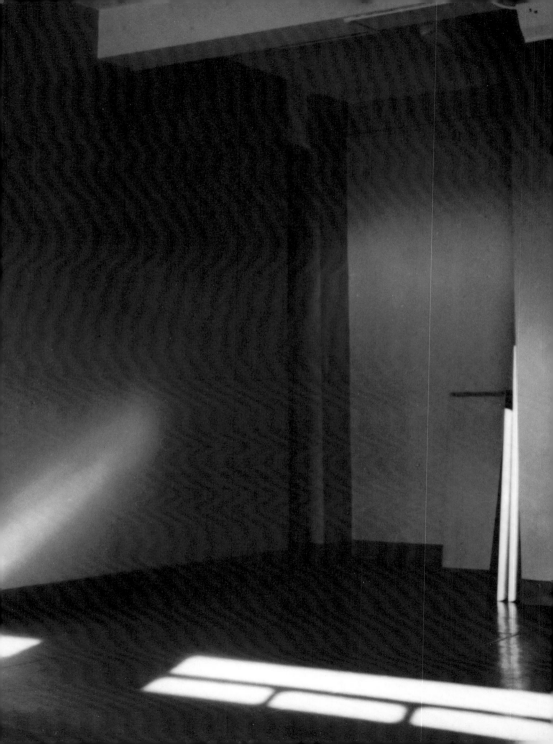

Printed in Japan.

Library of Congress Cataloging-in-Publication Data
Norman, Dorothy, 1905–
intimate visions The Photographs of Dorothy Norman
edited with an essay by Miles Barth; introduction by Dorothy Norman;
preface by Edward Abrahams.
p. cm.
Includes bibliographical references
ISBN 0–8118–0364–3
1. Photography, Artistic. 2. Norman, Dorothy, 1905–
I. Barth, Miles. II. Title.
TR654.N642 1993 92-21489 779'.092—dc20
 CIP

10 9 8 7 6 5 4 3 2 1

Distributed in Canada by Raincoast Books
112 East Third Avenue
Vancouver, B.C. V5T 1C8

Chronicle Books
275 Fifth Street
San Francisco, California 94103

Cover photograph: Dorothy Norman with Camera, 1932
Photograph by Alfred Stieglitz, gelatin silver print
Philadelphia Museum of Art: From the Collection of Dorothy Norman

The Photographs of Dorothy Norman

Edited with an Essay by Miles Barth
Introduction by Dorothy Norman
Preface by Edward Abrahams

CHRONICLE BOOKS•SAN FRANCISCO
In association with the
International Center of Photography, New York